HOME FROM THE CROWDS
AND OTHER CHRISTMAS POEMS

KEVIN CAREY

ILLUSTRATED BY KEVIN SHEEHAN

Sacristy
Press

Sacristy Press
PO Box 612, Durham, DH1 9HT

www.sacristy.co.uk

First published in 2014 by Sacristy Press, Durham

Copyright © Kevin Carey 2014
The right of Kevin Carey to be identified as the author of
this work has been asserted by him in accordance with
the Copyright, Designs and Patents Act 1988.

Illustrations Copyright © Kevin Sheehan 2014

All rights reserved, no part of this publication may be reproduced
or transmitted in any form or by any means, electronic,
mechanical photocopying, documentary, film or in any other
format without prior written permission of the publisher.

Sacristy Limited, registered in England & Wales, number 7565667

British Library Cataloguing-in-Publication Data
A catalogue record for the book is available from the British Library

ISBN 978-1-910519-03-5

www.jesus4u.co.uk

CONTENTS

Preface ...v
Musical Settings ..v

December ..1
Annunciation ...7
The Baptist's Cry ..8
John Herald.. 10
The Hush ... 12
Inns... 13
Christmas Eve ... 14
Stars .. 16
Be Still, Be Still!.. 17
Another Mary ... 18
Which Way Does The Wind Blow? 20
God's Love In The Flesh Of A Baby...................... 21
The Baby Kind .. 22
Right From The Start... 23
Real Bethlehem ... 24
Lily .. 26
Sweet Jesus .. 27
Strange Dreams.. 28
Emma And Jesus ... 29
Snow Falls ... 30
The Visit.. 31
Journeys... 32
Councils... 34
Innocents... 35
Homecoming .. 36

The Snowman And The Baby	37
Half Way	38
If We Could Change Places	39
Long Ago, Long Ago	40
O Gather	41
Tell Me The Story	42
Nativity And Passion	43
How?	44
Sparks	45
All The World's Music	46
Excuse Our Folly	47
The Kiss	48
Another Way	49
Body And Spirit	50
Hope	51
Dream	52
Spring Dream	52
Promises	53
Halo	54
'Tis Christmas!	54
Ruler Of All	55
Heaven Knows Why	56
Dunstaple's Bent Hand	57
Metamorphoses	58
Sonnets Askance	59

PREFACE

Anyone assembling a third collection of Christmas poems from a Christian standpoint cannot avoid—indeed, would not wish to avoid—the implications of the incarnation and, more specifically, the projection of the events in Bethlehem towards Calvary. The shepherds and kings and the other witnesses of the sacred birth still have their rightful and joyous place but, sooner or later, the unfolding of the full purpose of God in Christ must be confronted. Nor can such an author long ignore what the birth of Jesus tells him about himself and his purpose in creation and his hope of salvation.

This collection, therefore, cannot avoid taking on something of a sombre tone but I hope readers will not think less well of it for that. No biography of a great person—and Jesus is the greatest person who has ever lived—could be content with material simply covering the life of the child; we all want to know how the prodigy turns out, particularly if our lives depend upon it.

Kevin Carey
Hurstpierpoint, West Sussex
Pentecost 2014

MUSICAL SETTINGS

As with previous volumes, the verse in this collection can be readily set to music and it is the author's earnest hope that some of it will. The author would be very pleased to hear from composers who may be interested in setting any of these lyrics. Please contact the publisher if you would like to do so.

DECEMBER

i.

Dense, drizzle-laden mist rolls off the Downs
Closing the day early;
A pot of lapsang souchong's smoky tang
To warm and comfort through
The twilight hour of prayers to the first candle:

ii.

For all the year that's turned, half friends half lost
Already and the layered accretions of routine,
The gentle beauties of rare moments lacquered
Deepening the patina of what might have been.

Remembering this hour a year ago,
Slight resolutions and the books unread,
Failure to stir one day after horror,
The minor triumphs of the things unsaid.

A golden flame surmounts the purple column,
Atop the suffering may beauty shine
With the bright promise of your sacred mission
To alloy the human with the divine.

iii.

The wind across the sheep-strewn chalk blows almost
As sharp as frost
As velvet closes out the gathering gloom
Hugging the warmth
Against the probing draught that crooked candle flames
And lop-sided wax.

iv.

"Repent! Repent!
It's not rapacity that I resent
But pride
Which is too prominent for you to hide
Even when it is buried, deep inside."

Repent, repent.
The last time, not unnaturally, was Lent.
Reflections on the year
In cards and letters emphasise the fear
Of what we owe ourselves becoming clear.

"Repent! Repent!"
The fiery Baptist's torso, thin and bent
Swaying from side to side
Pours dirty water over gleaming pride,
With words so sharp they cannot be denied.

Aflame! Aflame!
Two hopes that things will never be the same:
The Baptist cries,
His message no surprise,
Self-knowledge bringing tears to our eyes!

v.

A break in the weather, powder, coral pink
On a sapphire cloth
Follows the winter sun over the rim
Of the upturned horizon:
Scarcely a Nocturne played
And the colours fade:

vi.

Home from the crowds,	A time to ponder
This day of gifts,	Time ahead,
The rose aglow	Advent purple
The purple lifts:	And Christmas red:
The open heart,	This rose fine tuned
Though lacking taste,	In cheerful voice,
Desires to please	Quietly intones,
In listed haste.	Rejoice, rejoice.

vii.

As if in wait for stars, the velvet sky
Falls silently
Towards the stealthily soundless whitening ground;
The flame's four points of light,
Have been completed;
The purple last, of Mary's humble crown
Heeding the Word:

viii.

Mother of Jesus, gentle and strong,
How should we praise your courage and loss?
How rank your fear when Gabriel came,
How feel your pain at the foot of the cross?

Who can resent the hymns in your praise,
The beauty of woman, the Lord at your breast?
Who can resist a prayer in your name,
For courage and comfort, for healing and rest?

Ave Maria.
Salve regina!
Alma redemptoris mater!
Stabat mater!
Ave Maria.

ix.

As Bach dies in the gothic vault of King's
 The first flake falls;
The candle, white as snow where all lines cross
 Flickers, then thrives;
Children are loud on their way to the crib
 —Angels and shepherds—
While the old walk slowly to a memory
 That is renewed
 And lives:

X.

At Christmas time fresh carols bring
To celebrate our new-born king:
Old rhymes and tunes we gladly hail
But over-usage makes them stale;
Staples baked into novel fare
Make us more lively and aware.
Our age wants something new to say
And we need different words to pray.
Frenetic, urban lives require
Recalibration of desire,
Nostalgia for a bygone age
Obscures our message. Turn the page
To bring new songs of hope and cheer
Refocusing to make it clear
That what we celebrate is more
Than emptying the superstore:
Earth has its king, now celebrate
With tribute, simple, short and straight.
So, sweep the cakes and ale away
For Green & Black and chardonnay.

ANNUNCIATION

Mary at prayer before the rising sun
Drowned in a blaze of light
Stutters and shudders in mid Antiphon
Rooted from taking flight:

O holy maiden, only choice of God
Whose blood, fused with the Spirit, was His blood.

Mary entranced by troubling messages
Clutches herself in fright
Wondering what the turmoil presages
How can she make things right?

O holy maiden, Mother of the Lord
Through whom the Flesh was answer to the Word.

Mary at prayer after the setting sun
Offers herself totally
Whatever trouble now God's will be done
Blessed eternally.

O holy maiden, dressed in Heaven's veil;
In graciousness, remember our travail.

THE BAPTIST'S CRY

The melancholy of unrealised hope
Crystallises in a wild man,
Saying what the heart has not quite said
Since time began.

The sore relentlessness of sacrifice
At last gives way to water and the Word;
Love is as yet unenshrined
But hope is heard.

The golden halo of the enriched
Encompasseth not the outcast:
Jesus we see as softening the harsh
Message of what will come last:

Cousins in warning and redemption,
Martyrs standing out against the barren strong:
A dirge more than a hymn
For a desperate throng.

Remember his solitude and prayer;
The times the angels were not there;
The grating prophet of discomfort,
Of the unthinkable prayer.

As he waxes I must wane
But now on Jordan's bank
Reality is far more pressing than the theory,
Or the exercise of rank:

All realisations are collective,
Built upon a single spark;
So little yet of formulation,
Humble we must address the stubborn dark.

JOHN HERALD

"We interrupt this programme to announce
The birth of, what our correspondent says,
Is a long awaited child; though far away
The wonders of satellite technology
Mean that we can go live to Bethlehem."
"The baby prophets promised has arrived,
Although the contrast could not be more stark
Between the dingy stable of his birth
And a quite remarkable new star outside.
The mother and baby are doing well.
Locals deny the landlord's explanation
That he had no room in his crowded inn
But say he was deliberately holding out
For higher prices during the census.
Insiders say the news will cause a stir
In courtly circles but a reliable source
In Jerusalem says there is no serious threat
To Herod's role as trusty of the Romans.

The sleepy town is suddenly awake;
And if I were not a down to earth man
I would say that the sound I hear is like
A heavenly choir (if I knew what it was!)
I am being approached by a rough looking mob
Of shepherds playing pipes, they must be drunk!
This is John Herald for the News at Ten."
"Well, that was very nice. But we must return
To much more serious matters. Now children
It's far too late already, time for bed
In order to give Santa a clear run.
A baby in a stable, fancy that!
Goodnight children! Sleep well! Goodnight, goodnight!"

THE HUSH

The hush before a baby's cry
Rolls restless scrolls of prophesy:
The quelling of the ancient storm
Makes seas grow calm and winds blow warm:
Yet God incarnate born to die
Alone amid hostility
Lies tightly swaddled in the straw
Far from the vision they foresaw.

A mitre and a kingly crown,
An altar and a golden throne
Encompassed in a feeding trough
Of nails coarse and timber rough:
A pipe but not a trumpet blown,
A wriggling lamb, all bleat and bone,
Imparts its feeble warmth but then
The new-born baby cries again.

The lord of all reduced to prize
His mother's breast and restless eyes,
All power decanted to retain
His solidarity with pain.
The vulnerable fool defies
The iron logic of the wise,
And echoes in his infant breath
The weakness of his pointless death.

INNS

Not two coins to make a jingle
As they crowd the festive inn;
Not a word to warm my spirits,
Just a blurred carousing din:
Here's a man, travel-worn and harassed
Seeking shelter for the night,
His wife, pale, pregnant and embarrassed
Cowering from the doorway's light.

Not two coins to make a jingle
As they crowd the Metro bar,
Singing with half-drunken voices
Of a baby and a star:
Here's a woman shouting "scrounger"
As she passes with a lurch,
Drops her Christmas hat and staggers
Up the steps and into church.

CHRISTMAS EVE

i.

So many angels fill the evening sky,
So many shepherds herding so few sheep
And more wise men than an academy,
But only one new baby, fast asleep!

Such treasured childhood memories are passed on
But are they more than sentimental show?
Only God knows what his own son has done
But it is more than human mind can know.

ii.

When the day is over
And the candles flicker
And the fire grows warmer
And the snow falls thicker,
She says:
"Think of your places reversed, my dear
You out there, the rough sleeper in here!"

iii.

When books are closed and grave thoughts fled,
The lights put out, the beckoning bed,
An image halts my wary tread:
A baby in a cattle shed.

He may be in a Trinity,
A brave trope of theology,
But what counts more is what I see,
God in a child of flesh like me.

I feel the prickling of the straw,
The roughness of the earthen floor,
Wind threading through the flimsy door,
But do not know how to be poor:
And wish I loved a little more.

Jesus, here is a little prayer,
As I approach the nightly stair,
Help me to care as I should care;
I think I might now you are here.

STARS

We the stars of ancient rites,
Lighting the Olympian heights,
With the Gods firmly entwined,
Have our sacred place resigned.

For a new-born star we see,
Free of all duplicity,
Shining for a God so pure,
All the others to obscure.

Not a God of war nor lust,
Whom all other gods mistrust;
Born kenotically weak
Whom the poor and lonely seek.

Mere ancient curiosities,
We reserve no dignities
But sparkle as a sacred sign
For the God who makes us shine.

BE STILL, BE STILL!

Be still, be still!
Our Lord is near at hand.
We are the servants of His royal will
And bow our heads to hear His quiet command.

Be still, be still!
Here comes the Prince of Peace
To rescue us from life's remorseless mill
And grant to captured souls their sure release.

Be still, be still!
Wake not the sleeping child,
For He must face the powers that curse and kill
So that all sinners may be reconciled.

ANOTHER MARY

Your azure veil and flowing gown
Suffused with God's eternal light
Conceal the ferment in the town,
The squalor of that fateful night:
Was it a star or smoking torch
That guttered in the stench and storm,
Was it devotion or debauch
Which filled the shepherds with alarm?

The angel Gabriel's embassy
And your inspired *Magnificat*
Speak of unflawed serenity,
Predestined by divine *fiat*:
But were your thoughts so wholly calm,
Confronted with the social shame,
And were you safe from hurt and harm
For what you did in Jesu's name?

That halo of serenity
Which marks you out as strong and meek
Conceals profound uncertainty
Which tyrants visit on the weak:
Had you heard rumours from the kings
That added grimness to your smile;
Did you recall the sufferings
Of Israel's children by the Nile?

Mary, for all the artist's art,
For all the beauty you inspire,
I love you for the young girl's heart,
The raw salvation of desire:
For in the guise of harassed grace
I see you daily in the street
With heavy load and tear stained face,
Unsteady shoulders and sore feet.

And I might never come to see
Your likeness in Our Saviour's face
If you were dressed like royalty,
Familiar but out of place:
But, as you are, I am not shy
To bring a gift to please your child,
For you, like Him in majesty,
Are love itself but slightly wild.

WHICH WAY DOES THE WIND BLOW?

Which way does the wind blow?
Over the snow
With an eerie Monet glow
And a donkey's shadow.

What say you of the skies?
A portent, I surmise;
And a happy surprise
Before sunrise.

What say you of a king?
Nought but a baby, angels sing
Sweet songs of welcoming.

GOD'S LOVE IN THE FLESH OF A BABY

Frost on angel wings
In the starry sky;
Joyful heaven sings
Of the victory:
Of God's love in the flesh
Of a baby.

Earthly powers frown
In their disarray;
What price now a crown
On this holy day:
Of God's love in the flesh
Of a baby?

Love wins over power
In their endless fight
If but for an hour
On this Christmas night:
Of God's love in the flesh
Of a baby.

THE BABY KIND

Angels above a sleeping town
Announce a king without a crown;
But only outcast shepherds hear
Of power that they need not fear.

And when they come to see their Lord
They tell his mother what they heard;
And she recalls her foretelling
Of justice that her son will bring.

And even though her words are dressed
In pomp unknown to the oppressed,
The message will not go away
No matter what the cynics say:

For what the town missed in the night
Was love embodied in the light
That shines in us for welcoming
A baby as our heavenly king.

RIGHT FROM THE START

Sharp blows the shepherd's pipe
Wild blows the wind,
Dark stands the cattle stall
Sleeping the king.

Bright shines the prophet's star,
Soft shines her face,
Warm breath the cattle as
Jesus awakes.

Cold lies the winter snow,
Warm beats her heart,
Blazing the Spirit's glow
Right from the start.

REAL BETHLEHEM

Now snow has gone
And the wet wind drives in from the sea;
Now stars are dim,
Cloud reflecting sodium ubiquity:
When soldiers guard
The Church of Your Nativity
And bombs explode
In nameless, inhumanity:
Then Bethlehem is our woe
Not seen in deep and peaceful snow.

Now sullen wind
And unremitting, probing rain,
Now warm unkind
Plays music in a restless strain;
When neon picks
The rags of beggars in the street
And tills not towers
Join battle for your last defeat:
Then Bethlehem is our home,
A town of empire worse than Rome.

Now Satan sweet
Tempts with a moderate appetite,
Now tiny feet
Are lethal in the red and white;
When we no longer
Learn from pain and suffering;
And feel much stronger
When our hold is weakening:
Then Bethlehem must be real,
A town of torment, torture, blood and steel.

LILY

A tender lily
Near translucent in the snow;
Near invisible
In the tugging wind blow.

How shall it stay
On such a cruel day,
Florid in May,
December in affray?

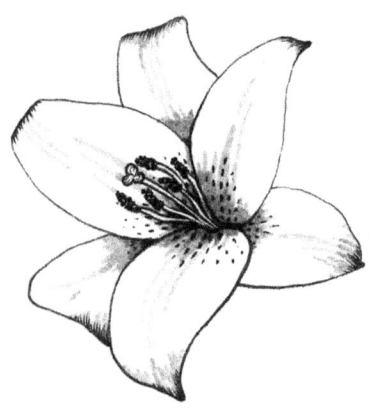

A tender lily
Translucent in the snow,
Heaven's pollen
In the wind blow:
It shall be
That of greatest delicacy
Shall withstand
The cruel hand
And flourish
In the barren land.

SWEET JESUS

Inspired by The Holy Well, sixteenth-century, anon.

Sweet Jesus said unto Mary
Pray give me leave to play
But fellows young and lusty said
We must avow Thee nay
For we in gentle homes were born
Thee in a manger lay:
Sweet little king
What suffering.

Sweet Jesus said unto Our God
I willingly will die
For humble man Ye made me be
My Godhead to empty:
Living as poor, not of the law,
Made more our victory:
Sweet little king
What suffering.

Now mother I am risen up
My father's Glory shown;
Richness hath come from poverty
More than ever man hath known;
And thou wilt play in heaven above
As it will be thine own:
Sweet little king;
What revelling.

STRANGE DREAMS

Strange dreams and strange voices
Strange omens in the sky:
Dark words and dark choices
From angels passing by:
Sleepless with dreadful premonitions
And sudden decisions.

Our life of relentless rhythms
Of family, work and festival
Is broken.
But God has spoken.

Bright dreams and bright voices
Bright the angel in the sky:
Kind words and kind voices
From the shepherds passing by:
God was my premonition:
And my decision.

EMMA AND JESUS

Emma in bed, half asleep,
Waiting for morning to come,
Cheekily taking a peep,
Warm in the comfort of home:
Hoping for snow in the night,
Listening for bells and a sleigh,
Muddled in drowsy delight,
Ready for her Christmas Day.

Jesus, new-born, in the straw
Only wants comfort and sleep,
King of the weak and the poor,
Vaguely aware of some sheep:
Angels have gone from the sky
Leaving it troubled and grey;
Then he awakes with a cry,
Greeting the first Christmas Day.

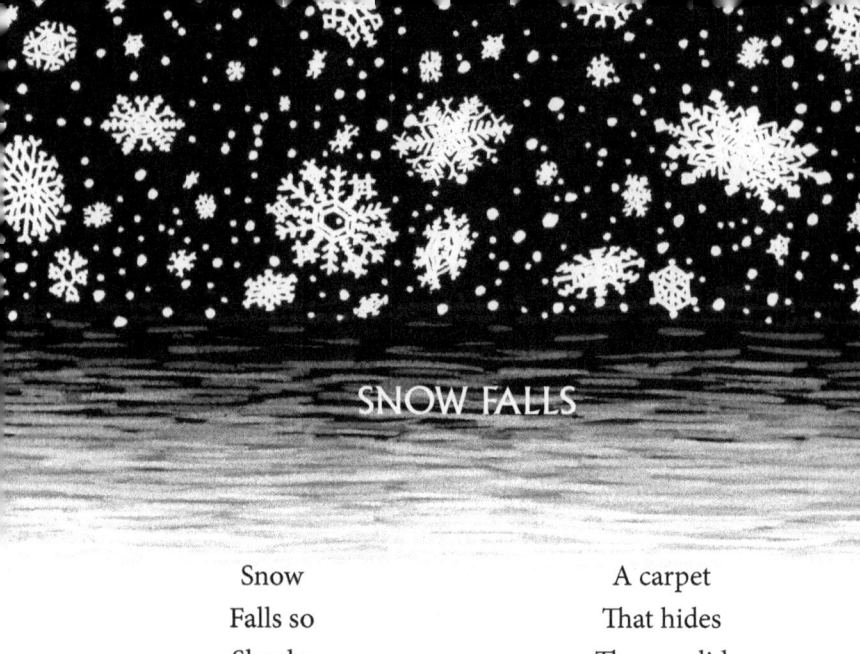

SNOW FALLS

Snow
Falls so
Slowly,
Softly,
First a blur
In the air
Then a denseness
Of light
And a carpet lies there.

A carpet
That hides
The squalid
And be-gentles
The soldier's tread;
A wondrous holiday
Of change
Before its unseamedness
is shed.

And though
There was no snow
Where he was born
I like to think
He knew
The special quality of light
And sound
On that special morning:
A hallowing dispensation
To the raw ground.

THE VISIT

Bright the candle
Sharp the spindle
Still the cradle,
Sparse the table.

Strangers errant
Orders trenchant
House in ferment
Hidden infant.

Gold effulgent
Incense pungent
Myrrh plangent
Threatening presents.

Light the candle
Turn the spindle
Rock the cradle
Lay the table.

JOURNEYS

Across the barren plain
From which hills look the same
Where camel tracks are rough
And sand shifts just enough
To bring disaster
I sleep in stolen shade
Then as the shadows fade
I see the comet's glow
Drawing me on to follow
Even faster.

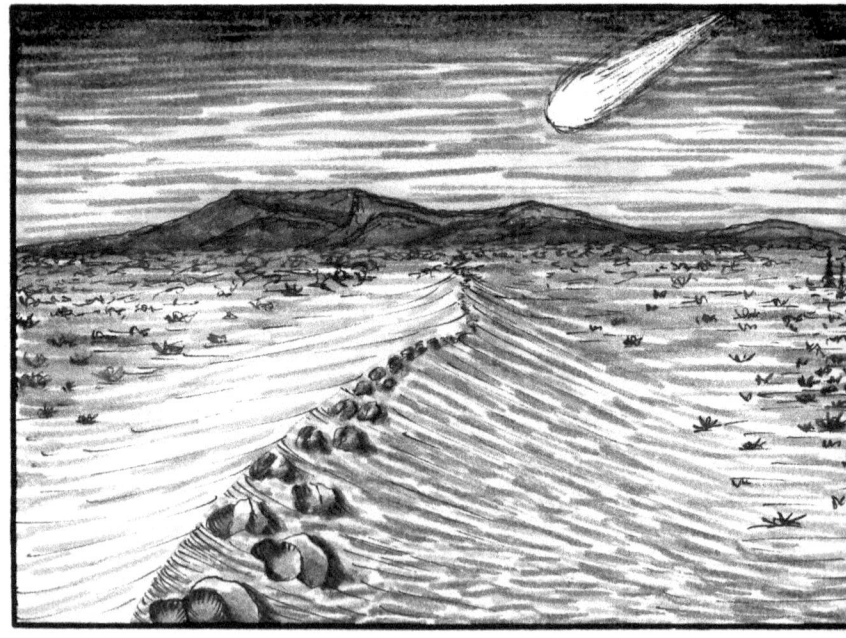

One night without a word
Our disparate routes converged,
Our camels formed a string
Our separate wandering
Woven into a band:
And as we looked ahead
To check what we had read
At once the comet flared
Before it disappeared
At journey's end.

Dawn roseate and calm,
Promising winter warm,
We took our cargo down
And each item was shown
To be exquisite:
Gold for a kingly price,
Incense for sacrifice,
Myrrh for the tomb fresh hewn,
The comet had not shown,
Ending the visit.

COUNCILS

The spy said:
"There is a strange pattern in the movement of kings,
Connected, somehow, with heavenly happenings."

The mandarin said: "There is a strong prospect of a King of the Jews,
We think it best to keep this out of the news."

The Guard said: "We could easily handle any civil unrest;
But think pre-emptive violence would be best."

The Council said: "Force is required because the case is so urgent;
But it will not set a precedent."

The King said: "Stability is more important than blood;
Let all the infant boys die for the common good."

The NGO said: "We have tried to preserve the rights of the child;
But those who escaped death have been exiled."

INNOCENTS

Blood on the grimy snow,
Tears on a faded shawl,
Flesh for the status quo
Spat from a marble hall:
Mothers that did not know,
Martyrs that heard no call,
Names scratched in shadow
On a tottering wall.

Death, calibrated, slow,
Strikes in a lethal squall,
Hovels reduced to a glow
Mock those on whom they fall:
Murder the world came to know
Power could not forestall;
Exiled so long ago
He still dies for us all.

HOMECOMING

Half known but still unknown,
Frayed patience at false starts
The sages con their ancient charts,
Their prize the measurement and span
Of time and fortune known to man,
The tyrant and the throne.

Such unrelenting rules
For such a crucial rite
Fearing to question what the stars invite;
An extraordinary king,
Reckoning after reckoning:
Heroes or fools?

Home, dusty and shattered
Cracked chests and stoved-in casks,
Hoping to circumvent what duty asks
About that mysterious child too
Subtle for a measured view
Of whether it mattered.

THE SNOWMAN AND THE BABY

A snow man anchored in the snow
From which it came to be
Dies unremarked, silent and slow,
A transient history.

A baby bathed in radiant light
Of which it is the source
Dies violently in day made night
As love encounters force.

Yet we will always live in light
Building in love although
Our efforts will be cold and slight
Because we build in snow.

What we construct time will destroy
As transient works of earth
Rehearsing everlasting joy
Made solid by that birth.

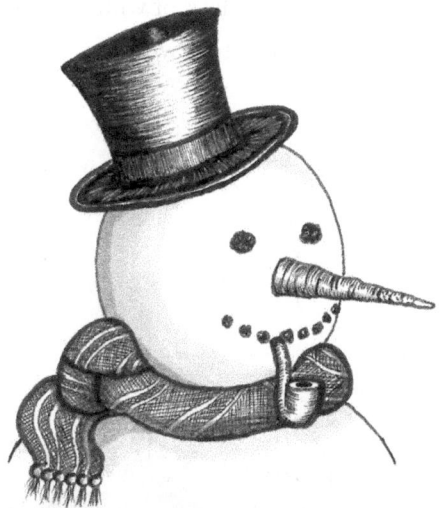

HALF WAY

Half way between the darkness and new light,
Between numb winter and the thought of spring,
When joy and sorrow strive on Simeon's brow
It is of a fair maiden that we sing.

Between the wooden manger and the cross
The berry fractures and its poison flows,
Spattering its grief upon a maiden's cloak;
We light a candle to recall her woes.

Between His incarnation and the carnal,
She hovers in the fire, human bright;
Not probing in the dark of winter gloom
But blackening the cross with Easter light.

IF WE COULD CHANGE PLACES

If we could change places
And I had your power
You would be sleeping
In a warm, scented bower:
Not wrapped in poor swaddling
But pleasant in silk,
As white and as warming
As your mother's milk.

If we could change places
And I had your power,
We would be watching
From a tall, granite tower:
Not frozen in terror
But safe as the spring,
The Lord over Herod
And Israel's King.

If we could change places
And I had your power,
I would give it all back to you
With my small store:
For love is the power
To set the world free,
Not cold and conditional
But full endlessly.

LONG AGO, LONG AGO

Fingered by the searching cold,
Cutting wind on cruel snow,
Born not far from death was he
Long ago, long ago.

Threatened by King Herod's wrath,
Lashing out to find a foe,
Fled, not far from death was he
Long ago, long ago.

Strange the story that was told
Of the desert and the snow,
Poor, outcast and suffering
Long ago, long ago.

Were he born in luxury,
Servants passing to and fro,
Could he know my suffering
And how hunger lays me low?
He is mine for what he bore
Long ago, long ago.

O GATHER

O gather sweet flowers
For the young maiden there,
And weave them in garlands
To put in her hair:
And embrace the young man
So shy and sincere
For their imminent wedding.

O gather sweet straw
To give him soft rest,
And moss for a pillow
And milk from the breast
And wrap him in in sheepskin
That the shepherds have dressed
To greet his coming.

O gather sharp thorns
For the criminal's head
And make him a crown
For the king that he said
He was but in five hours
This king will be dead
Ready for entombing.

O gather bright stars
To embellish his throne
And that of the maiden
Who bore her sweet son:
And round them we gather
Our hearts all in one
Joyful at his rising.

TELL ME THE STORY

Tell me the story. I am cold
And need to know that He was too;
That he suffered the world's sufferings,
Even worse than me and you.

Tell of the shepherds in the night.
I need to feel their dreadful fright;
And know how angels brought the news
Of freedom from the world's abuse.

Tell of the gifts the wise men brought,
That all their riches came to nought;
But that their worship at his shrine
For all their rank but equalled mine.

Finish the story. I am weak,
Losing the strength to think or speak;
But he was killed by and for me,
Bitter the taste of mystery.

NATIVITY AND PASSION

Thy tiny feet are pierced with nails,
Thy halo has made way for thorn,
The lash, not the caress, prevails,
The angel choir descends to scorn.

Thy mother saw both joy and loss,
Thy stable was a tomb in wait,
Thy paltry manger made a Cross,
Thy Census scroll a plaque of state.

The Shepherds' lamb, thine own device,
The ass returned to seat a king,
The Magi gold a silver price,
Thy birth a final
Reckoning.

HOW?

How can we hear his wakening cry
Yet still not hear him in each child?
The victim smeared with the fault,
The outcast vilified as wild.

How can we watch the shepherds kneel
Yet patronise the humble deed?
The poor blamed for their poverty,
The rich admired for their greed.

How can we track the wise men's star
Yet chase each glittering fantasy?
The calm rejected for the shrill
And wisdom for celebrity.

And yet we will do all these things,
Bowing before pride's tinsel throne;
Yet he who lies before us now
Has come to claim us for his own.

SPARKS

Glittering lights
All bright and cheery
On winter nights:
Joy on parade,
All neat and tidy,
Encouraging trade.

Candles are quaint
But somewhat risky,
Requiring restraint:
There's something un-English
About being holy,
It's best to extinguish.

Sparks are a nightmare,
Random and oblivious,
Falling just anywhere:
Love and fire,
Out of control,
Far worse than desire.

ALL THE WORLD'S MUSIC

Sing all the world's music,
Pray all the world's prayers,
Bring all the world's beauty
To picture our lord:
A birth in the silence
A night full of fear,
Then light, words and music
Only shepherds could hear.

The word of the angel,
Good news for the earth,
Not quite comprehending
The wonderful birth:
Their music the angels,
A baby their prayers,
A life changing moment,
Ours as well as theirs.

EXCUSE OUR FOLLY

Gentle Jesus,
Excuse our folly
Wrapping your birth in tinsel glare,
Decking your crib with sprigs of holly,
Filling your stable with reindeer.

It should be enough
To keep the plain,
Perhaps a halo, nothing more;
To live in mystery, not to explain,
To celebrate as if we were poor.

Send the Holy Spirit
To find us a quiet place
For a little prayer,
And in a lowly place,
To find you there.

THE KISS

The kiss of a snow-flake
Softens the steely gloom;
A spark before daybreak
Shoots from a blazing womb:
A cry from the timeless
Breaks into common time;
A star's mystic brightness
Announces the sublime.

Shepherds, shepherds tell me
What did you see?
A vision in the sky
Of angels passing by
A voice fulfilling
Every prophesy.

A baby lies sleeping
With shepherds all around;
His mother is weeping
In joy, without a sound;
The star is so bright
It sweeps the gloom away,
As this sacred night
Turns into hopeful day:

The star promises kings
With precious offerings
Of gold and incense rare
And the foreboding of myrrh,
The glory and the sadness
That it brings:

But set your eyes upon a higher throne
Of glory that until now was unknown,
On beauty that no earthly power can clone
And flawless love that earth can never own,
The promise that we will not be alone.

ANOTHER WAY

No angel can console
Be it so proud and bright
Nor can the star enlighten
The darkness of this night:
For what was born in wonder
Is dead upon the tree,
The innocence of Ephrath
Engulfed at Calvary.

The candles for the virgin
All sputter in the rain
The laughter of the fishermen
Turns into doubt, then pain:
When back at the beginning,
The message was so clear,
But in the carnage of the Cross
It seems to disappear.

No angel can reveal
Be it so meek and coy
The Risen Christ's return
And our eternal joy:
Yet could there still have been
A way to spare His breath
In Ephrath's dark manger
And His even darker death?

BODY AND SPIRIT

Hope's distant light
Makes misdeeds sore;
Pride's slick fix lit
By the day longed-for.

The Easter wonder
Is far too bright;
Our misdeeds fade
In ethereal light.

Hope in a child
Surfaces shame;
Our failings lit
By a candle flame.

The empty tomb
Makes the spirit wild;
But the body yearns
For the little child.

HOPE

Treading the broken way with care,
Scanning for a smoking flare,
Even the checkpoint seems welcoming,
Though hardly fitting for a king!

For winter is more sour than sharp
As canker creeps and door frames warp;
A chronic mildew in the manger,
Laid out of danger into danger:

> And then the sky explodes in blaze
> Of light to frighten and amaze;
> And rumours of good news confound
> Those who would keep their feet upon the ground.

>> Then shepherds with the gift of speech
>> Spout like the prophets to a screech,
>> As sneers of ridicule deny
>> The message that the angels,
>> Yes, the angels
>> Poured down from the sky!

And in the game of holy chess,
The crib in all its wholesomeness,
I try to sink to where He lay,
On prickling and sodden hay: For if there is no thought to grieve,
 I hardly think I could believe,
 Humility being all I crave,
 And hope beyond my unkept grave.

DREAM

Sleep my love against
The old wind blowing out,
Dream of the new wind sent
To blow the proud about.

Sleep my love until
You hunger for my breast;
Dream of a life of love
To comfort the oppressed.

Sleep my love unless
You know more than I know;
Dream of the heaven sent
To us below.

SPRING DREAM

Each flake so perfect
Seen alone
Then settled on one
Of myriad thrones
Carpeting earth's thorns and stones
With a beauteous mantle.

A moment to sing
Of the king
But blood is dripping
Upon the sheen;
Beauty grown cruel and biting cold;
And the child dreams of spring.

PROMISES

Upon the brow of a barren ridge
A donkey etched against the sky,
Its burden shot through with labour pain,
Its guide cajoling passers-by.

"No room," they say. "Blame Caesar's tax.
But there's a place where the cattle stay."
And meek as peasants must learn to be,
They settle down upon the hay.

A smoking lantern for a nurse,
Rough bands of cloth to adorn a king,
A shepherd's pipe to announce the birth,
A doleful fanfare for suffering.

Upon the brow of a barren ridge,
Three crosses etched against the sky,
Their burdens ravaged with dying pain
Insulted by the passers-by.

One figure bows his grieving head,
Another, crowned, says: "Come, be with me."
And what God promised in Bethlehem
Was put in doubt at Calvary.

And yet my story has one more twist,
That Christ who died rose from the dead;
And sent the Spirit to take his place;
Thus doing everything he said.

HALO

The golden halo round his head
And satin bright as flowers,
Are marks of power inherited
To signify his heavenly powers.

But pretty as the scene might be,
Depicting pomp and fuss,
He set aside his dignity
And came here as one of us.

'TIS CHRISTMAS!

Hear the church bells ring out!
Hear the organ shout!
'Tis Christmas!
Satan is shut out!

Hear the angels sing!
Children caroling!
'Tis Christmas!
Hail the infant king!

Hear the baby cry.
Hear a lullaby.
'Tis Christmas.
God on earth to die.

RULER OF ALL

I heard of his birth
Long after the drama,
Hope for the whole earth
In a baby so poor.
I heard the old story,
Embellished and reverenced,
When the shepherds lacked money
To settle their score.

I made my escape
To the unfriendly city
Where oppression and rape
Were my lot as a whore:
But I heard what he said
On the steps of the Temple
And remembered his bed
In the Bethlehem straw.

Just for old time's sake
I watched his last moments
And felt the earth quake
As he made his last call:
But the news of his rising
From the tomb of the dead
Was hardly surprising
For the ruler of all.

HEAVEN KNOWS WHY

Heaven knows why
Such a sweet child
Should make me cry.

Now fast asleep,
The words I heard
Still make me weep.

Saving is such
A trial for Him
Who loves so much.

DUNSTAPLE'S BENT HAND

The damp wind melancholy moans
Informing Dunstaple's bent hand.
How should we be so full of woe
In such a green and pleasant land?
Why, eastwards the impassive sun
Sees flocks diminish in the sand,
Where one more precious than the rest
Was slaughtered at our harsh command.
O sweet lamb, born in poverty
Beyond what we can understand,
How should we celebrate your birth,
Escaping from the brash and bland,
How worthily receive your gifts
Cascading from your pierced hand?

O lamb, whose cry in Bethlehem
Promised to mend so great a tear;
O lamb, who died yet comforts me,
Accept this sad and wild prayer
That in between the two extremes
Of celebration and despair
I will attain a middle way,
Knowing that I will find you there.

METAMORPHOSES

Slipped from a cloud's womb I am, falling
As the pilot raindrop of a sharp shower.
Growing colder and whitening in harder softness,
As I slow down, as I drift lower.

A metamorphosis, I am told, although
I never hope to see such summer beauty
As the butterfly emerging from a chrysalis,
To live a brief and radiant life; then die.

I touch another life of beauty when I reach
The earth, the first flake to set upon
A tavern's stable yard in Bethlehem;
A thaw, and I am soon gone.

The chrysalis of a persecuted man, broken
Upon a cross becomes the Easter butterfly,
So radiant, with its white and gold and veins
Of blood; and it will never die.

SONNETS ASKANCE

i.

"Ne had the apple taken ... taken been,
Ne had ... Our Lady abeen heavene queen."
The retrospective pieces fit too neatly
Too blatant a re-writing of history
As if the God/Creator simply craved
A way to damn us so we could be saved
By his own agent, something of a son,
Through whose death at our hands, our freedom won.
Better to think the apple made us free
To love him and each other fitfully,
Better than angels fixed in their degree,
Forging our brittle solidarity:
Ne'er had the apple been neither would we
Have been more than the blossom on the tree.

ii.

Exhausted by the ordeal of the knife
And fire but waxing faster than his son
Abraham sees his revivified wife
And wonders what advantage he has won.
Another angel: trouble on the ground
As if there were not enough overhead:
He hears the stage whisper of heavenly sound,
Trying to understand what is being said:
As many as the stars that he can see,
As many as the grains there are of sand,
Are promised but his fragile progeny
Is traumatised beyond what they can stand:
Still, what the Lord has promised must occur;
God is an act not a philosopher.

iii.

A promise flickers in the dying flame,
Flaring before the room is left in dark,
God will not grant another lightning spark,
Content to leave his people to their shame
- Death, when it comes, is a catastrophe
Not lessened by the hopes of prophesy -
But being left is unlike leaving off:
The impulse is to promise and explain,
To lend collective meaning to the pain,
Vaguely adducing hope when times are tough:
Maidens will conceive and bear in due course
And one is set apart, a special force:
The people will rejoice if it prevails,
But be no wiser if the gambit fails.

iv.

Turned from the rising sun she kneels to pray,
God before nature at the break of day,
Bent on retaining the residual gloom
But restlessness assaults her Psalmody
As light behind closed eyes, brighter than day,
Transports her from her prayers and the room
Into a heavenly realm where a dark voice
Offers what seems to be a holy choice
Although, suspicious of her carnal need,
She hesitates before timid assent,
Knowing that both her families will be bent
On ostracising her for the misdeed:
But, blazing in her womb, the Spirit sears
Her with belief and all doubt disappears.

v.

He could not think what made him say "The lamb
Of God" when what he wanted to say was "The ram",
Religion being cruel to be kind,
Entwined with sin, the lot of humankind:
But he had heard his cousin's quiet voice
Cut through the self-aggrandisement of men,
Secure in ritual for power's sake,
Telling his wondering audience to rejoice
As if the world was free to start again,
With promises he knew that they would break
Jeshua and he were poles apart on sin
And he knew soon he would have to give in:
He scarcely felt the hand that bids him bless
Him in a gesture of futile redress.

vi.

The planetary weather, glittering, slow,
Subverts the human sense of time and space
Rendering the wildest hurricane effete,
Although the converse seems to be the case
- The human record of catastrophe
is nothing to a dying galaxy -
Each celebrated in the alien snow
And in a star exploding out of place,
Combining to produce a flawless sheet
Of frigid calm, misrepresenting grace
As if snow were on an aesthetic par,
Of equal beauty, to a glittering star:
But each needs each as both were made by him
Who knows them now, far from the cherubim.

vii.

Sing, angel voices in the winter storm
The news you bring of charity and calm
For we have sung our penitential Psalm
And crave good news to keep us bright and warm
Although we know the price was dark and cold,
A lowlier birth than any we have known
In turbulence, far from your heavenly throne,
Of squalor unpromised in things foretold,
Easy to subvert with haloed veneer
When children's fancies should be set aside
To celebrate only with modest cheer
Knowing that God as man was crucified:
Our Christmas will turn bitter in the spring
If we expect to crown this child as king.

viii.

Bad news always arrives sooner than good:
Soldiers despatched in haste always bode ill,
Not least when they ride out before the spring
When keeping warm and quiet is their aim;
But Herod's fear is worse than his bombast.
All life below his tottering rank is fair
Game if killing it will keep him there.
They reach their cowering objectives at last
And murderously seal their master's fame
With innocent blood that questions who is king.
Is Herod suffering a lust to kill
Or one whose motives are misunderstood?
Against the precept that he would present,
We rank the outcome higher than intent.

ix.

Blood in the gold that only he can see,
Standing like undressed liver on a slab,
No better met head on than like a crab,
A molten lump of jumbled cruelty.
Smoke from the frankincense meant to obscure
The craft of self-styled supplicants blows clear
To show the priestly tribute from the poor,
In exquisite attire, smooth yet austere.
Myrrh hovers at the edge of every crowd,
Not willing to be shunned as morbid fare,
Yet always presaging that final shroud
That splits its victim into earth and air:
Whatever they had brought would be the same,
The flaw His father wrought in heaven's frame.

x.

How clear the joyful bells across the snow
Made sweeter by the rarity of cold
As winters wet and windy overthrow
The paradigm of Christmastide of old
Call most of us in vain to Midnight Mass,
Content with glib and clichéd caroling,
Grown ignorant of how Christ will surpass
Our mundane hopes, of why we pray and sing,
Yet when the bells fall silent and the elves
Have smothered Jesus in a scarlet coat
Making our memories of Him so remote
That we think we are here to save ourselves
He will be born again to save us all
Even if we no longer hear his call.

xi.

The blackened organ staves of knotted chords
Assault the plangent dissonance of the choir
Producing music few minds can retain
Or voices render, dismembering words,
Substituting intellect for desire,
Roughening the places that were made too plain
With coats of nineteenth-century sentiment,
A brightly coloured pageant, in the snow,
Surbiton layered on Florence on Palestine,
As if the stable were a monument
To public virtue and the status quo
Domesticating Christ and the divine:
What carols shall we sing or pictures paint
Wrought with humility and self-restraint?

xii.

Long after cribs have given way to trees
With Father Christmas as our winter king,
And gadgets as our only deities
And presents as the joys of which we sing,
When Bethlehem's star is dimmed beyond our gaze,
Obscured by smoke and artificial light
And angels decorate but never praise
Upon fading nostalgia's special night,
A glib reversion to the pagan ways
Before they were transmuted into love,
When people were intent upon the ground
And not what might be sent down from above:
Though God will have to save us from the elves,
More, we will need to be saved from ourselves.

EU GPSR Authorized Representative:

LOGOS EUROPE, 9 rue Nicolas Poussin, 17000 La Rochelle, France

contact@logoseurope.eu

www.ingramcontent.com/pod-product-compliance
Lightning Source LLC
Chambersburg PA
CBHW070451050426
42451CB00015B/3436